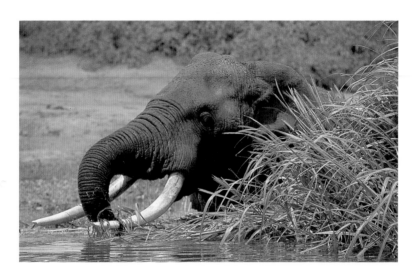

ONE MORE ELEPHANT

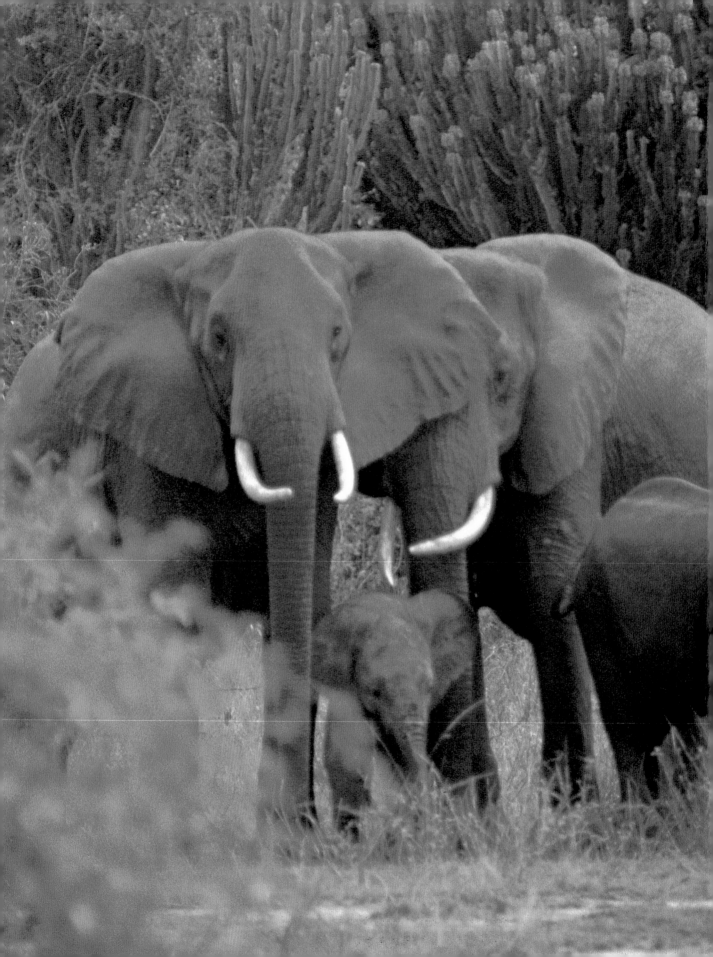

ONE MORE ELEPHANT

The Fight to Save Wildlife in Uganda

Written and photographed by
RICHARD SOBOL

COBBLEHILL BOOKS
Dutton/New York

For Ronnie Mae

Library of Congress Cataloging-in-Publication Data

Sobol, Richard.
 One more elephant : the fight to save wildlife in Uganda / written
and photographed by Richard Sobol.
 p. cm.
 ISBN 0-525-65179-9
 1. Wildlife conservation—Uganda—Ruwenzori National Park—
Juvenile literature. 2. Endangered species—Uganda—Ruwenzori
National Park—Juvenile literature. 3. Elephants—Uganda—
Ruwenzori National Park—Juvenile literature. 4. Moeller,
Wilhelm—Juvenile literature. 5. Moeller, Peter—Juvenile
literature. 6. Ruwenzori National Park (Uganda)—Juvenile
literature. [1. Wildlife conservation. 2. Elephants. 3. Endangered
species. 4. Moeller, Wilhelm. 5. Moeller, Peter. 6. Ruwenzori
National Park (Uganda)] I. Title.
 QL84.6.U33S63 1995
 639.9'7961'096761—dc20 93-45663 CIP AC

Published in the United States by Cobblehill Books,
an affiliate of Dutton Children's Books, a division
of Penguin Books USA Inc.,
375 Hudson Street, New York, New York 10014

Designed by Charlotte Staub
Printed in Hong Kong
First Edition 10 9 8 7 6 5 4 3 2 1

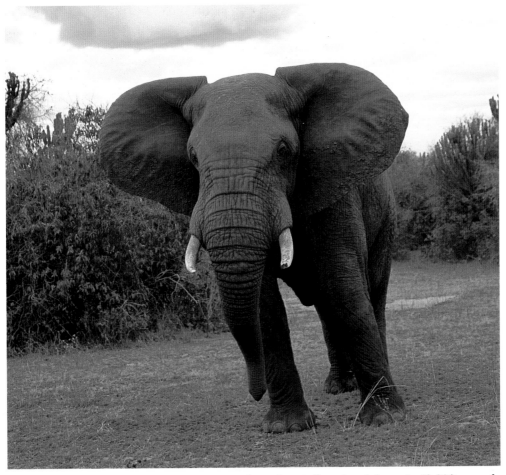

Elephants can stand ten feet tall and weigh up to 12,000 pounds.

Why have elephants captured the imaginations of so many scientists, artists, photographers, and children around the world? Anyone who journeys to see them in the wild comes away awestruck by some unique part of their personalities.

It could be their size. Elephants stand ten feet tall and weigh up to twelve thousand pounds. Even a basketball star would need a ladder to see over their tall backs.

It could be the sharp, piercing blast that elephants make as they blow through their uplifted trunks. When this trumpet sounds, it sends out rolling waves of thunder. Each blast is filled with deep vibrating notes. Once heard, it is a sound which is never forgotten.

It could be the playful scenes of water squirting wildly about as the herd bathes together, remaining in the water to play long after they have finished drinking or cooling off.

It could be their tight-knit family structure and sense of community. Traveling together as a family, the entire herd may slow down or wait several days in one area for a sick or weak member of their group, taking turns to push or pull them along.

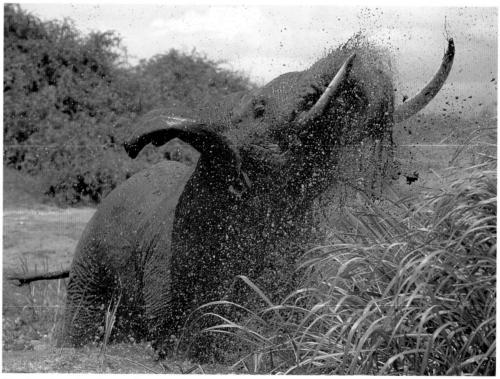

Elephants enjoy the water.

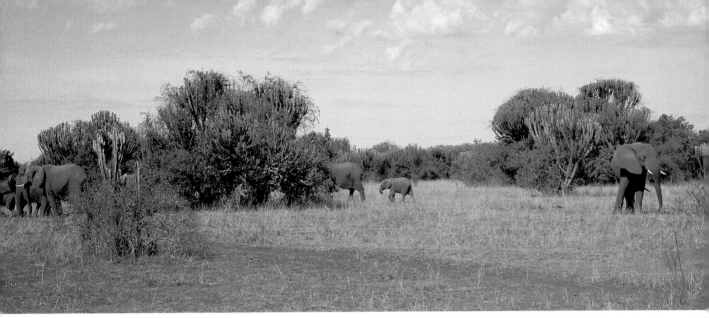

Elephant herd

Today many of these scenes are becoming harder and harder to find. The great herds that filled the vast African plains and the gentle hillsides of Asia have been reduced to a small shadow on the landscape. These great beasts, which throughout history have been viewed as the symbol of the strength and freedom of wildlife, have paid with their lives for jewelry, piano keys, chess pieces, and souvenirs that are carved from their long ivory tusks.

Throughout Africa special areas have been set aside to protect the wildlife and insure that the way of nature will not be upset. These sanctuaries, centered around the idea that the needs of animals come first, are "national parks." People can enter to observe and study as long as they are respectful of the rules of the park, rules that are set up to protect the animals.

One of these wildlife sanctuaries is Queen Elizabeth National Park (also known as Ruwenzori National Park) in Uganda. For many years Uganda was the most popular tourist destination in Africa. This lush green country, sitting astride the equator at the foot of the Ruwenzori Mountains deep in the heart of Africa, was a safe haven. Visitors from all

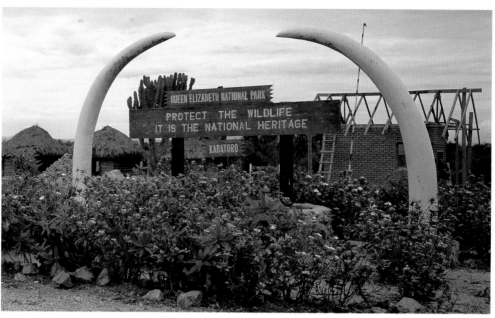

Queen Elizabeth National Park

over the world would come to enjoy the company of some of the largest herds of elephants, hippopotamuses, crocodiles, buffalo, and birds to be found anywhere. When these visitors came to observe the wildlife, they also helped the local economy as they purchased food, rented hotel rooms, and hired local guides. A balance was kept, as native people received benefits from the wild animals that lived alongside them. This all changed when civil war broke out and the ruthless leader Idi Amin took control of the country. Amin was rough and brutal, killing thousands of people, especially those who disagreed with him. His army spread fear throughout the land, taking the law into their own hands. For ten years the country fell into dark times as a series of civil wars and political power struggles were fought. The wildlife of Uganda also suffered greatly during this time as military camps were often set up right inside the

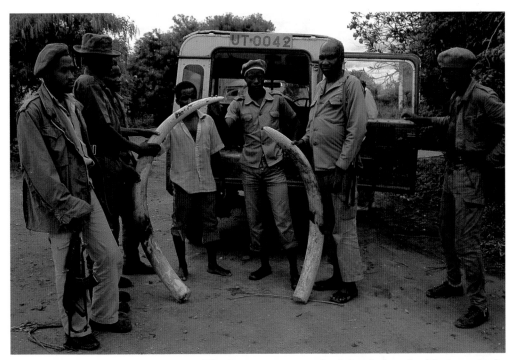

Elephants were poached for their valuable ivory tusks.

national parks. When soldiers were hungry they would kill elephants and other animals for their meat. When they needed money for guns and bullets, the elephants alone were their targets. Ivory could be sold quickly and the elephant tusks became the fuel that fed the fires of war. Eight out of every ten elephants in Uganda were killed to pay for bullets and bombs. Over ten thousand were slaughtered during this difficult time.

The delicate balance of nature was thrown off center and the national parks no longer served as sanctuaries. Queen Elizabeth National Park had become a battleground.

In 1986 the fighting ended and a new leader, Yoweri Museveni, came into power, restoring some peace to this war-torn land. Around this same time, two brothers arrived from Germany to make a film about the animals in the Ugandan national parks. Peter and Wilhelm Moeller had seen the parks and wildlife of Uganda in earlier years and they were shocked at what they found now. When they reentered Queen Elizabeth National Park, they found that this wildlife sanctuary, which had been filled with life, had become a desperate place. Hungry villagers had become poachers, illegal hunters feeding on the few remaining herds of

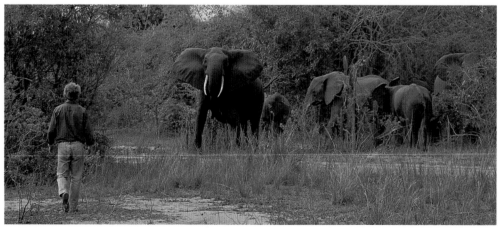

Wilhelm in the bush with an elephant herd

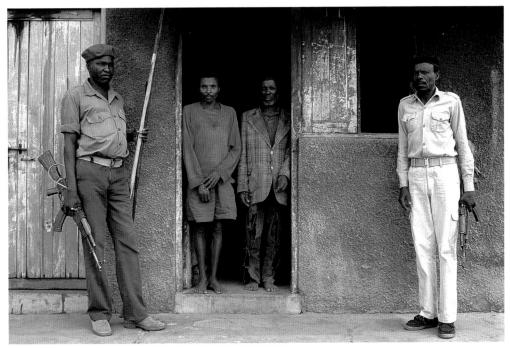

Rangers with two poachers who had been caught with a dead antelope

elephants, hippopotamuses, waterbuck, and kob antelope. At the same time ivory tusks were still being smuggled out of the country and sent to the carving workshops of Hong Kong and Japan, where the ivory industry was centered. The elephants were on the edge of extinction. Of the three thousand elephants that had been living in this national park, only one hundred and eighty had survived.

As the Moellers set to work on their film, they knew that what they were seeing would change their lives. This was not just another wildlife film to them anymore. Without having to speak about it, they each knew that they had to stay on. The fight to save the elephants of Uganda had become their fight.

Wilhelm started by writing a plan to control poaching within the park. He consulted biologists and conservationists from around the world,

seeking advice. Uganda was not alone in this crisis. Throughout East Africa and Asia the elephant populations had been dramatically decreasing. The worldwide demand for ivory had created a network of organized poaching gangs which roamed the savannas in search of elephant herds. Queen Elizabeth Park was unique, though, as the slaughter here was just short of total. If the elephants could be saved here, then there were lessons to be learned and shared with the community of wildlife conservationists and biologists throughout Africa. The park was to become a living laboratory.

Wilhelm's plan was simple—the poachers had to be stopped and conservation education had to become a priority. It would be the responsibility of people like the Moellers and the local wardens and park

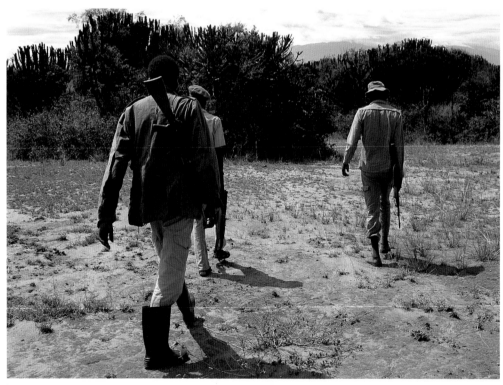

Park rangers on patrol

rangers to regain control of the sunbaked open spaces where the few elephants remained, while others would work from modern offices to reduce the demand for ivory products.

Peter took to reorganizing the park rangers. During the years of war and political unrest, they had survived for long periods without pay or support from the government, staying on because this was their home. They had no place else to go. Only eighteen remained out of an original team of one hundred and fifty. Now they were a sorry group, lacking weapons, working vehicles, and, at times, even food. Many of the rangers themselves were probably among the worst poachers in the park. When Peter pried open the rotting wooden door to the rangers' headquarters and he saw what supplies they had, he didn't know whether to laugh or to cry. It was pitiful. Broken-down jeeps, piles of flat tires, an assortment of antique rifles, and some rusty cooking pots. This was to be a big job.

As Uganda struggled to rebuild itself, the government could just barely afford to pay the salaries of the rangers (three dollars each, per month) but had no money available for equipment. Wilhelm looked outside Uganda for help. He began by sending a stream of letters to animal conservation groups around the world begging for vehicles, weapons, and money to be used to fight the poachers. Although he would

Local village, Uvenshava

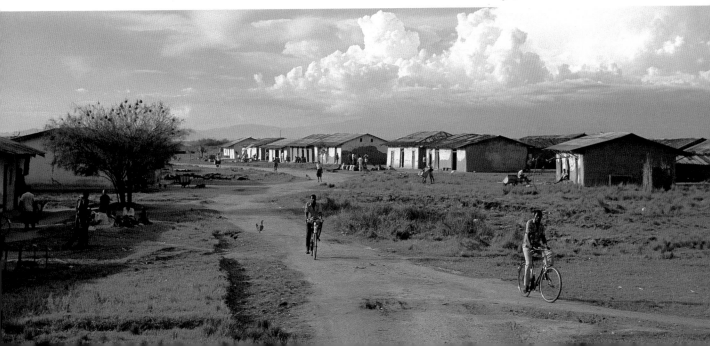

Chief Warden A. J. Latiff

have been delighted just to get shoes for the barefoot rangers, he was so persuasive in his appeals that one group of people actually arranged to send six used German army trucks, massive six-ton vehicles that could roll over almost any landscape. With these and the support of the newly formed Uganda Department of Wildlife and Tourism, they were ready to begin a new battle to protect the wildlife in the park.

The park rangers were being trained in military-style combat to be the first line of defense in what was considered to be a new war against the

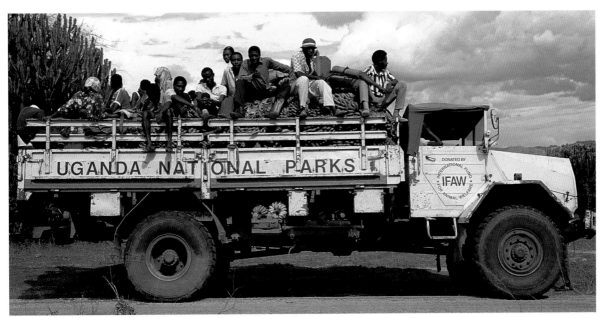

Trucks bringing food to the rangers and their families.

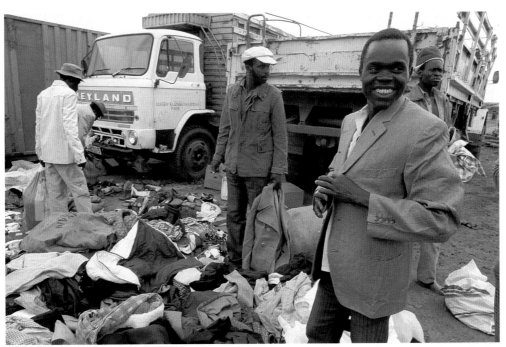

Picking out clothes

poachers. The skills needed to track down and capture the poachers were taught and rehearsed day and night. Keeping these hard-working rangers fed was now an unexpected problem to be solved. Since no farming could be allowed in the national park, the nearest food supplies were found in neighboring villages five or six hours away. The first trips made by the all-wheel-drive combat vehicles were quite simple. They went to the crowded, open-air markets, deep in the countryside and returned loaded up with bananas, potatoes, rice, and chickens for the rangers and their families who lived in small encampments within the national park. At the same time, clothing and supplies were arriving as donations from people around the world who had read Wilhelm's letters. With all this, the rangers could begin regular patrols, often hiking hundreds of miles on the lookout for poachers or animal traps.

At first they found traps everywhere they went, dozens at a time. These were quickly removed. The traps used by poachers are often cheap and primitive and can cause great suffering to an animal that wanders into one. The most common is a snare trap. These are made of heavy loops of wire which are tied between two trees on heavily traveled animal paths. The rangers also found cruel leg-hold traps which are placed under-

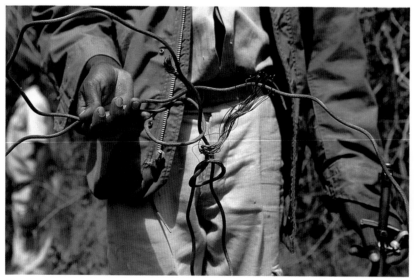

Snare trap

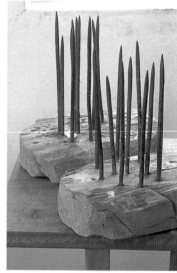

Trap taken from poacher

Fields burned by poachers

ground and grab tightly onto a foot or paw as an animal grazes or runs. After being caught, these animals slowly die from blood loss or may wait in pain until the poacher returns to kill them from a safe distance with a poison-tipped spear or knife. Many times the rangers were too late, finding the sun-bleached bones of hippopotamuses butchered for their meat or elephants with their tusks hacked out.

Often poachers burn the fields in order to drive the animals to smaller grazing lands or areas outside the boundaries of the protected parklands. Under the heat of the African sun, these fires are impossible to control. When they see smoke, the rangers hide out nearby and wait, hoping to capture the poachers before they make a kill.

The Moeller brothers and the rangers have captured over six hundred poachers. The worst of these, the elephant poachers, are now in prison. Some of the poachers, though, are ragged, simple villagers in pursuit of meat for their families. When they are caught, they are often kept in the park and offered jobs before they are handed over to the local police. They

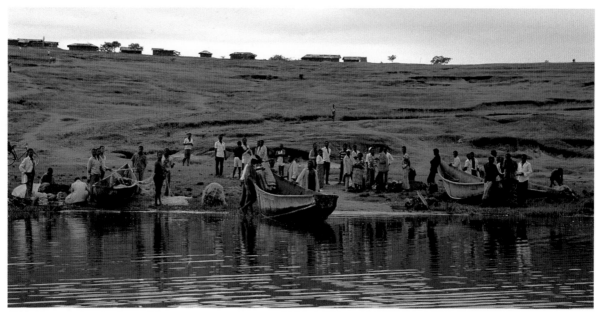
Villagers and boats

are also educated on the importance of wildlife and tourism for the survival of their country. Once exposed to the ideas of wildlife conservation they are less likely to poach again. With a little bit of food and some new knowledge, it is hoped that these former poachers will work to protect their wildlife legacy, not destroy it.

Peter Moeller has a soft spot for stray or orphaned animals and he is often called to villages outside of Queen Elizabeth National Park to help with animals that are sick or young ones that have been separated from their mothers. The local people usually have no experience with caring for animals and he comes out to rescue and reassure them. His backyard has become a nursery to a young elephant and buffalo that he has temporarily adopted. Once, as he watched the hysterical reaction to a baby elephant that wandered into a village, he realized that most of the people who live on the border of the park had no understanding of the native wildlife. He and Wilhelm responded to this by developing an education

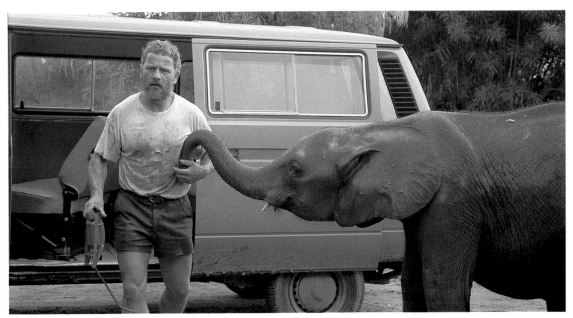

Peter with adopted elephant

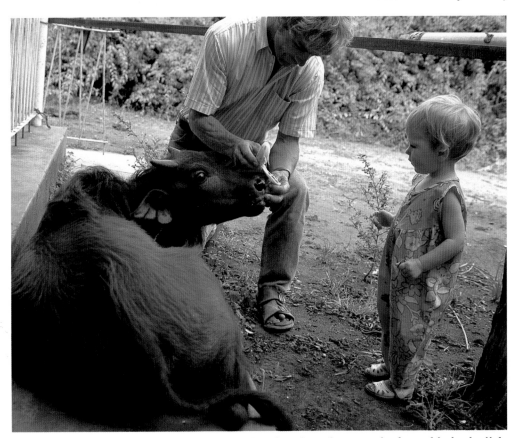

Wilhelm with his daughter, Inna, and adopted baby buffalo

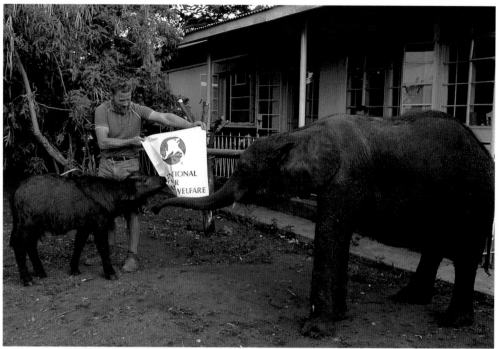

Peter with elephant and buffalo

program that brings local schoolchildren into the park on safaris. Each month hundreds of children are brought in for an overnight visit which includes game drives to see the elephants and antelope, boat tours of the hippopotamuses, and studies in conservation and ecology. It will be these children who live in the land that borders the national park that will need to be protecting it in the future. A few of them have already asked to begin training as park rangers.

After more than six years of work and struggle, the results of Peter and Wilhelm's efforts are easily seen. Today life within the park is beginning to take on a natural rhythm. As visitors slowly return, the blackboard outside the park headquarters displays a variety of daily wildlife sightings. Even the death of an animal in the park is no longer cause for alarm.

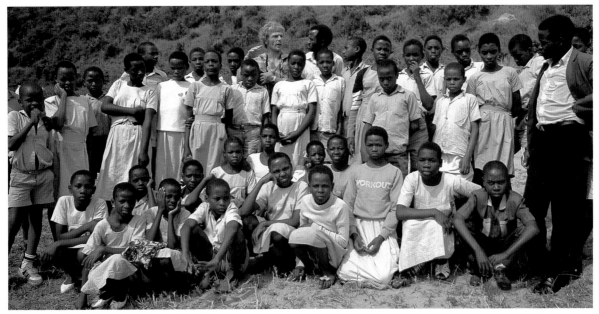

Local schoolchildren visiting the park

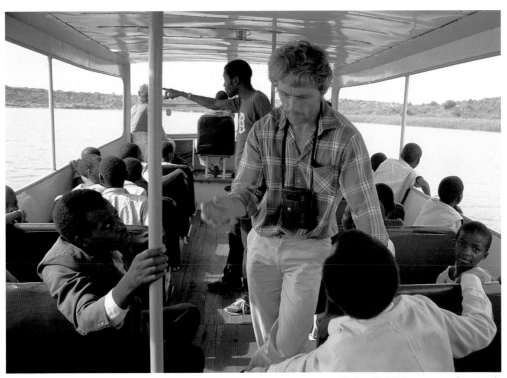

Schoolchildren on a boat trip

Natural deaths, in balance with the laws of nature, occur more often now than those caused by the unlawful acts of poachers.

There are reasons to be hopeful about the future of Queen Elizabeth National Park. Large crowds of hippopotamuses lounge along the shore of Lake Edward and feed endlessly on the grasses of the Kazinga Channel. Trumpeting clusters of plump elephants are found bathing and feeding outside the park's safari lodge at Myewa, returning to the same spots each day. The elephant herds move slowly, ever watchful of the new calves. Their population in the park is now over four hundred strong. With the birth of each new calf, the elephants seem to be saying that they are here to stay.

This is a beginning. It is still too soon to know if the elephants will survive here. Their future depends as much on the desires of people far

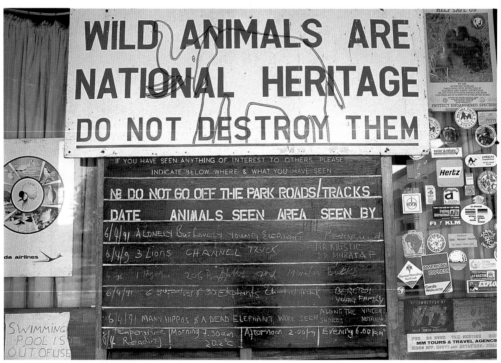

Bulletin board listing sightings in the park

22

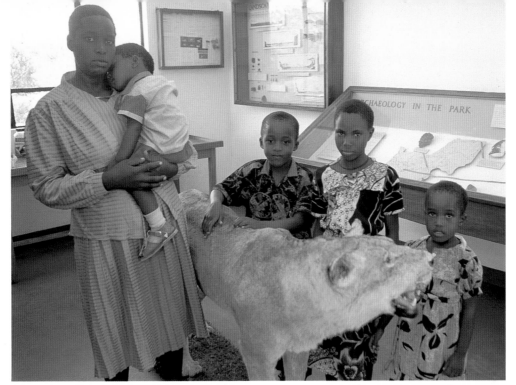

Families visit the park museum

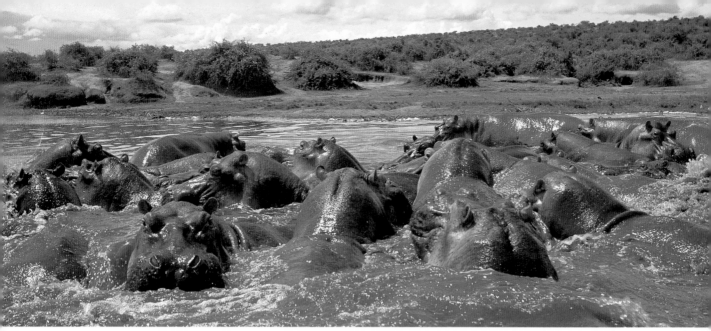

Wildlife in the park, crowd of hippos . . .

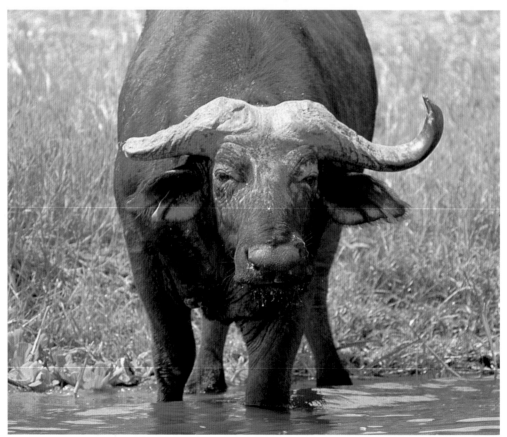

. . . black buffalo . . .

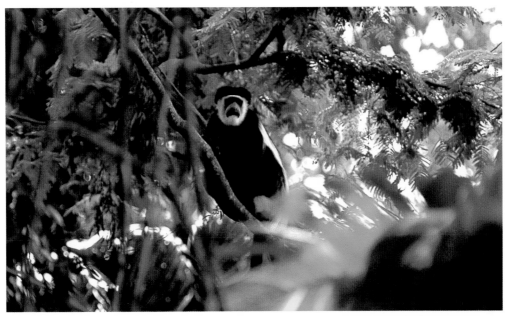

. . . black-and-white colobus monkey . . .

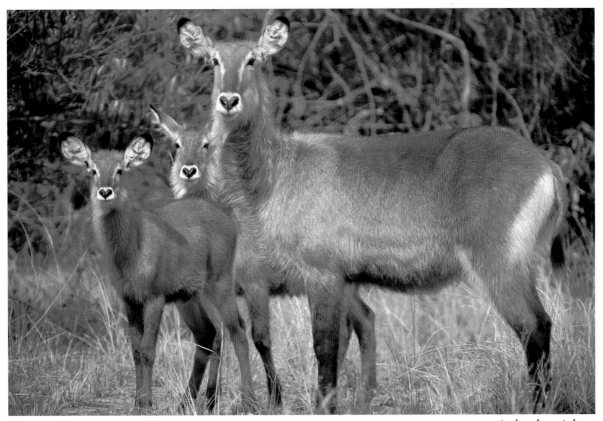

. . . waterbuck antelope

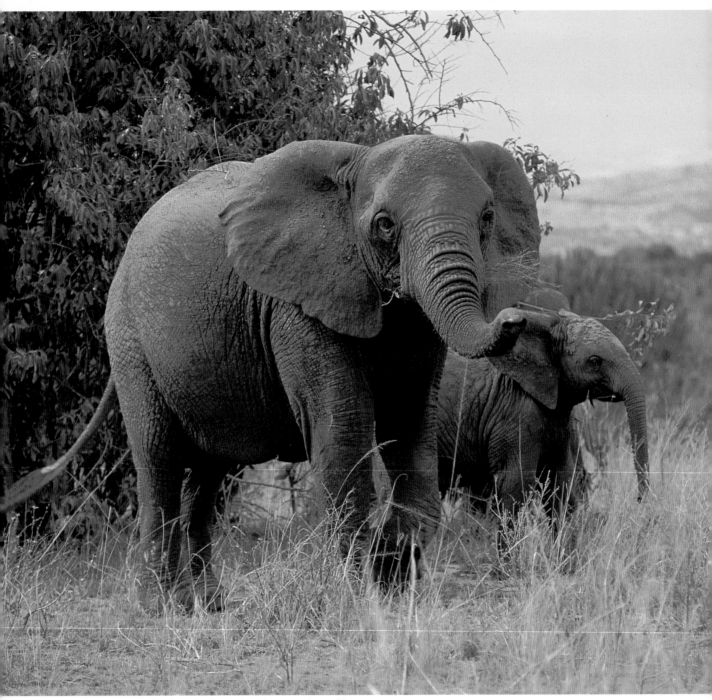

New calves in the elephant herd are a sign of hope.

removed from the African plain as it does on the actions of those in the park. Those who would still buy ivory must understand that the glistening carved necklace in a downtown gift shop came from the lifeless remains of an elephant thousands of miles away. Only when the demand for ivory is eliminated will the elephant be safe.

And for Peter and Wilhelm, there are three other national parks in Uganda that still need their help. . . .

MORE ELEPHANT FACTS

There are two basic species—the African elephant and the Asiatic (also known as the Indian) elephant. They can be recognized by their different shapes. The back of an African bends down in the middle; the Asiatic goes up in the middle. The Asiatic also has two bumps on its forehead. Another trick useful for identification is that African elephants have larger ears that are shaped like the continent of Africa and the Asiatic have smaller ears which are shaped like India.

Elephants are the largest of all land animals.

Average weight is 12,000 pounds. Average height is 10 feet tall.

The largest elephant ever recorded was over 12½ feet tall and weighed 22,000 pounds—as much as 150 average people.

Elephants move together in herds. Each herd has an acknowledged leader, usually a female, known as the matriarch.

Starting about age twelve, females can give birth every four to six years, producing about seven offspring during their lifetimes.

Elephants feed on green leaves, branches, fruit, the bark of young trees, salt and minerals dug up from the ground. Each will consume over 100,000 pounds of food and over 15,000 gallons of water each year.

Elephants have six sets of teeth. When one set wears down from chewing, the next set replaces it. When the last set wears down and the elephant can no longer eat, it will die from starvation.

Average life span is sixty years, although due to the pressures of poaching and hunting, very few have died of natural causes in recent years.

The trunk is the longest nose of any animal and contains 40,000 muscles.

Elephants can make a variety of sounds such as trumpets, growls, snorts, squeaks, rumbles, and roars. The sounds convey information to other elephants.

Tusks are incisor teeth that grow long. They are used as digging tools, breaking up the earth to look for roots and scraping bark off trees. In the dry seasons elephants dig in sandy riverbeds to search for water. After the elephant herd moves on, other animals are able to survive by taking advantage of these newly formed watering holes.

Elephants can run twenty-four miles per hour for short distances—twice as fast as any sprinter.

Current worldwide estimate of elephant population is around 650,000—625,000 in Africa, 25,000 in Asia. Fifteen years ago the total estimate was 1.4 million.

It is against the law to buy or sell ivory today in the United States, Canada, and one hundred other countries around the world. Since this "ivory ban" took effect in 1990, the price of ivory has dropped from $150 per pound to $5 per pound. This price drop has put most elephant poachers out of business.

Acknowledgments

Many thanks to the people who helped make this project possible. First and foremost to Peter and Wilhelm Moeller for their guiding skills, hospitality, friendship, and patience during my visit to Queen Elizabeth National Park. Their ability in finding boats, planes, trucks, land rovers, and fuel in a sparse environment is magical.

My travel mate Dr. Petra Deimer provided insight into the biology of the elephants, the politics of wildlife conservation, and rescued me with language translations.

I am endebted to the International Fund for Animal Welfare for their support of this project and for their continued support of the work of Peter and Wilhelm in Uganda.

For advice and assistance throughout this project thanks to Richard Moore; Paul Seigel; Brian and Gloria Davies; Jimmy Colton, Director of Photography at *Newsweek*; Eric Edroma, Director of Uganda National Parks; A. J. Latiff, Chief Warden at Queen Elizabeth National Park; Betty and Art Bardige; Sharon Grollman; Joshua Rubenstein; Jon Slater; Hans Franciskowski; Dale Peterson; Rosanne Lauer; and Peter Laharshmont. Special thanks to Steve Brettler for looking the other way.